WOMANTHOLOGY

★ ★ ★

HEROIC

SKETCHBOOK

ARTWORK INSPIRED BY, AND FOR, THE ANTHOLOGY.

TEA TOTALER

Written By: Rachel Pandich
Art By: Kate Carleton

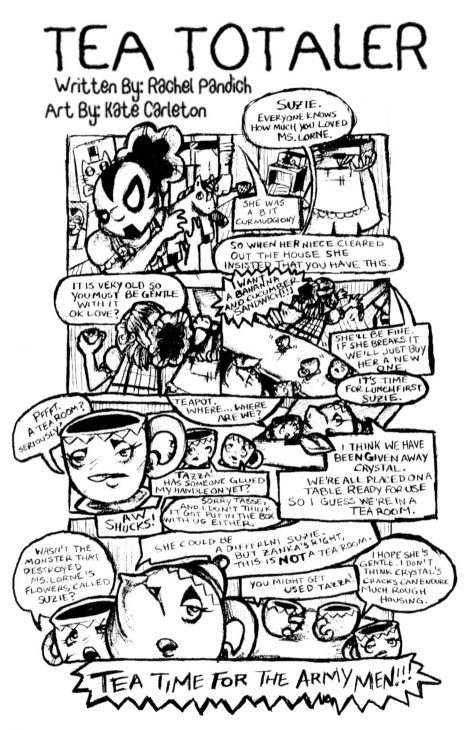

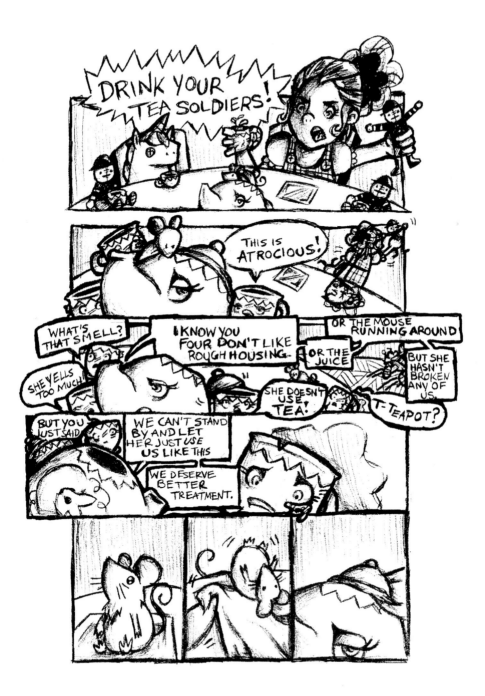

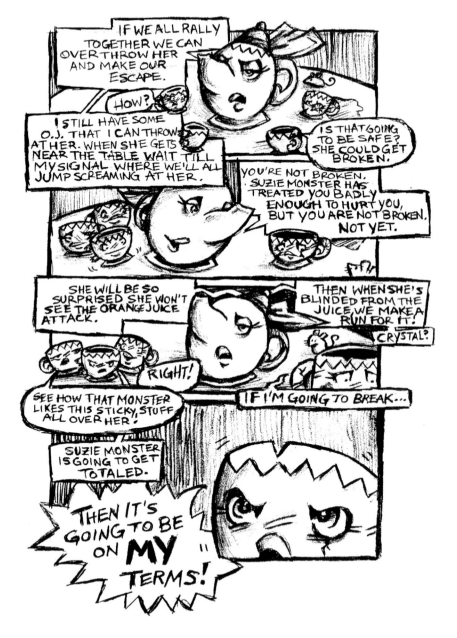

3

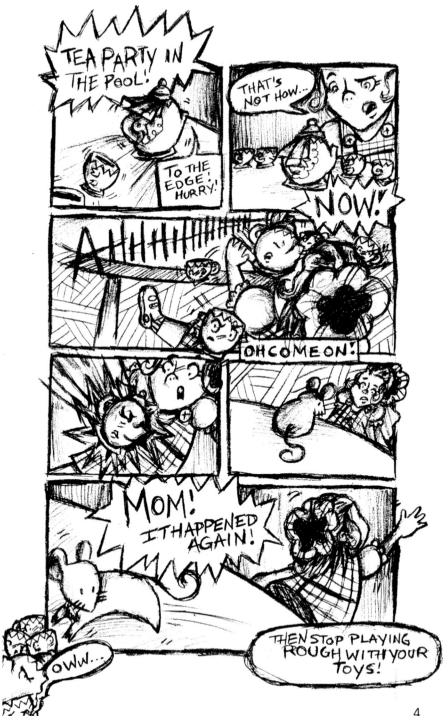

4

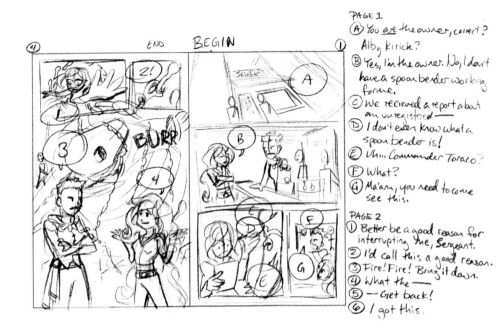

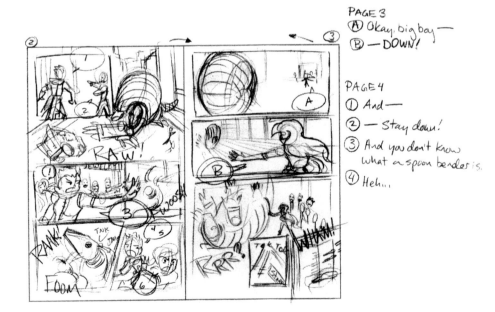

PAGE 1
(A) You <u>are</u> the owner, correct? Alby Kirick?
(B) Yes, I'm the owner. No, I don't have a spoon bender working for me.
(C) We recieved a report about an unregistered—
(D) I don't even know what a spoon bender is!
(E) Uhm Commander Toraco?
(F) What?
(G) Ma'am, you need to come see this.

PAGE 2
① Better be a good reason for interrupting me, Sergeant.
② I'd call this a good reason.
③ Fire! Fire! Bring it down.
④ What the—
⑤ —Get back!
⑥ I got this.

PAGE 3
(A) Okay, big boy—
(B) —DOWN!

PAGE 4
① And—
② —Stay down!
③ And you don't know what a spoon bender is.
④ Heh...

Sarah Elkins artist
Jennifer V writer

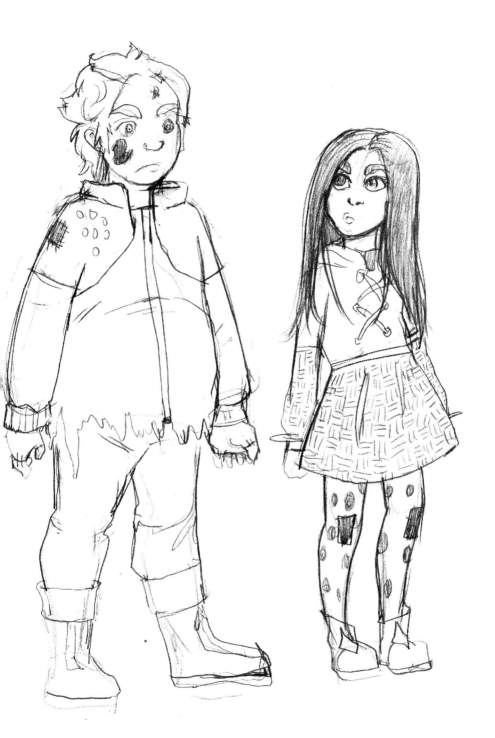

Jennifer Weber artist

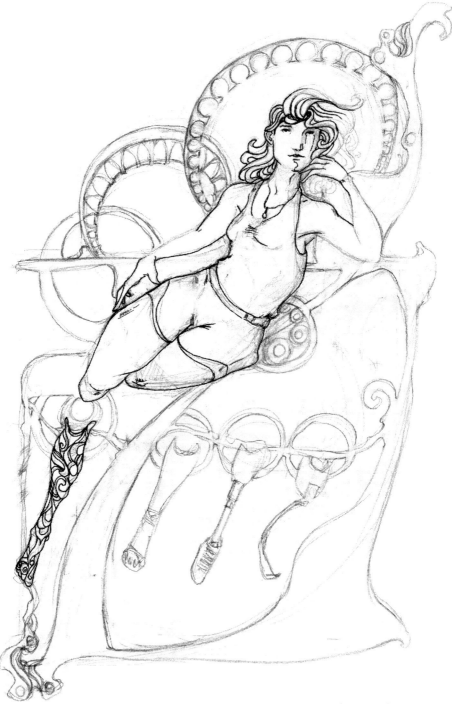

Beth Sparks artist

Adriana Blake artist

Kathryn Whiteford artist

Christianne Benedict artist

PAGE 2

PANEL 1

Wide shot: Full view of the circus, showing the APPRENTICE falling very close to the net and the crowd of CLOWNS around the clown car.

PANEL 2

Small panel inside 2.1, close up: an INJURED CLOWN is being pulled out of the clown car. The CLOWNS crowd around the INJURED CLOWN, biting their nails, holding their hands to their face like they are holding back worry.

PANEL 3

Close up panel, inside 2.1: a doctor checks the INJURED CLOWN, he looks like he has been crushed.

PANEL 4

The APPRENTICE is in the net. "THE ACROBAT APPRENTICE" rope nettin see a bright light shining out window. panel permits-the CLOWNS are busy. see the light.

PANEL 5

APPRENTICE has opened the clown car APPRENTICE's face, framed by side out, showing her reaction. A investigating, is replaced by

PANEL 6

Wide shot, largest panel on page through the car door opening, but inside of a car, her head and the ope floating in mid-air, in the middle of a emo d m stylized world. Hearts, angel wings, bu tentacles, and round, empty-eyed, facele s are some of the themes that fill this bright landscape.

PANEL 7

The APPRENTICE is walking thr trees and willow-banged leaves butterflies and sweet little po ith wings, flutter by. Cutesy anima towar PPRENTICE blank eyes.

Ma'at Crook writer
Blue Delliquanti artist

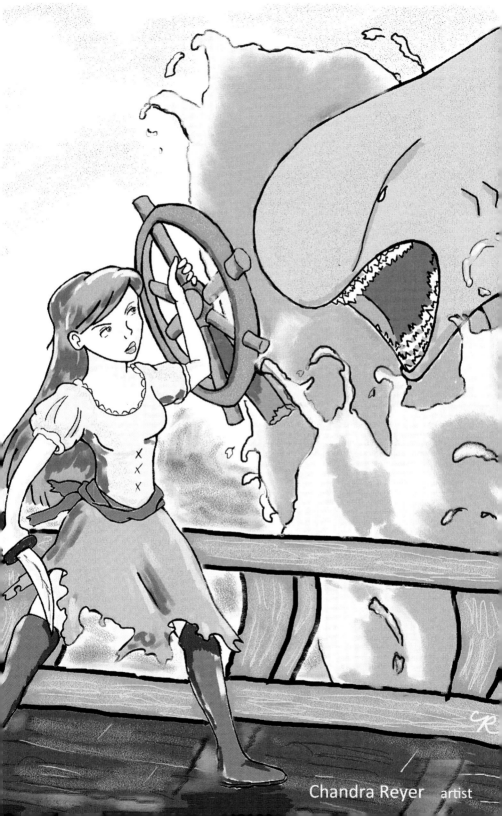

Chandra Reyer artist

Panel 3. Insert of a close up of the woman's face, a look of pure terror overtaking her features.

WOMAN (whisper):
No.

Panel 4. We see what the woman's looking at, a young child kneeling on the ground crying as the robot looms over her, foot raised about to step on her.

MEGAN:
Mommy!

Panel 5. Another low angle shot, the little girl looks up to see that someone has stopped the robot's foot yet the person is obscured by a rolled up piece of paper.

CAPTION:
-generated by a source of great good.

PAGE TWO From this point forward, the art is a finished product. Panel 1 should be vertical, long enough to reach the second row of panels.

Panel 1. AMANDA, a teenager who despite her attitude doesn't draw attention with her appearance, sits up from her sketchbook. Amanda's annoyance is clear as she looks over her shoulder at a table of laughing teenagers. They all have that air of arrogance of the preppy crowd: jocks, cheerleaders and other a-typical popular kids. They are sitting in a cafeteria, a wide space with large windows.

JOCK:
Bunch of freaks.

CHEERLEADER:
And their queen.

SFX:
HA! HA! HA! HA!

CAPTION:
Evil exists in many forms, some more obvious than others.

Panel 2. Flip the shot allowing us to see who is sitting at the lunch table with Amanda as she flicks the paper away. Her friends are a mixture of outcasts: rockers, goth kids and geeks.

Goth Kid:
What is their problem?

Punk Kid:
Too high off their own fumes of arrogance.

Katie Bernard writer

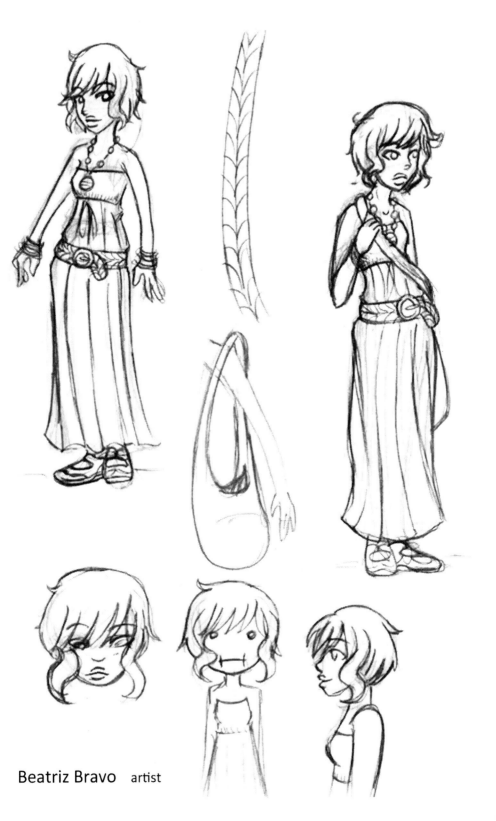

Beatriz Bravo artist

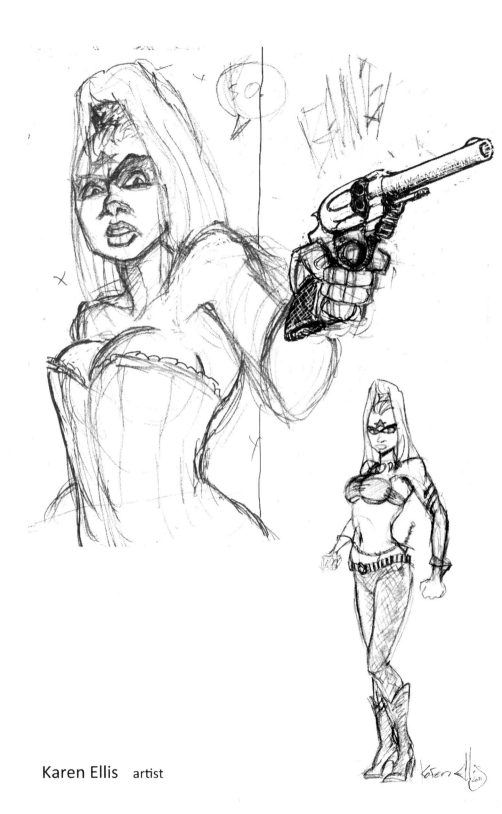

Karen Ellis artist

How It Really Happened
An Octobriana story
script by Trina Robbins

Page One

Panel One

Splash panel. Interior of a big fancy ballroom with a big fancy staircase, candles burning in crystal candelabra, etc. Richly overdressed aristocrats circulate, drinks in hand. Two richly overdressed women in ballgowns of the period, lots of ruffles and lace please, converse in the foreground.

CAP: December 16, 1916

CAP: The Yusipov Palace, Petrograd

Speech balloon from outside panel: Their excellencies the Grand Duke

Overdressed woman #1: My dear Baroness Rosen, how well you look.

Overdressed woman #2: And you, my dear Countess Ignatiev. How is the Count?

Panel Two

This is a small panel, set into the larger panel at the bottom right.

Closeup of the two women, as they turn towards the outside-panel voice, looking puzzled.

Outside panel speech balloon: The Baroness...Countess...um, Princess...er, Octobriana!

O.D. Woman #1: Who?

Trina Robbins writer
Karen Ellis logo

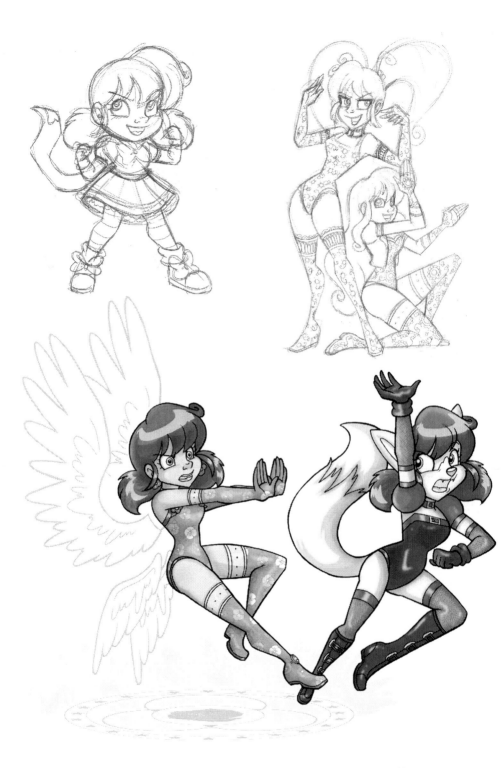

Mary Bellamy artist

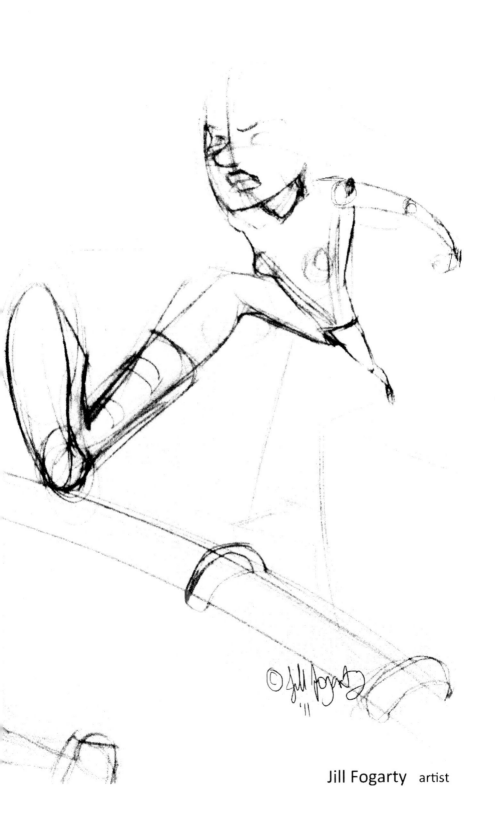

Jill Fogarty artist

"Womanthology Script 1"

1. there is a spring pouring out of a rock face
2. a woman's bloodred hand reaches into it
3. we turn to see the woman trying to wash off her opposite arm, the source of the blood
4. she turns in panic at a noise behind her (to the side of her)
5. a man gentlly emerges from the trees saying her name
6. she recognizes him and calms down
7. but it degenerates into crying with her hand over her face
8. he rushes over to comfort her
9. she asks why he came, he says because he was scared
10. ~~the~~ he couldn't believe they'd set the dogs on her , he had to find her before they died ~~we see him setting dogs on her~~
11. he says he was worried he wouldn't find her because he almost lost her scent ~~or teeth~~
12. she's anxious, he says don't worry, they're safe for now — she delayed them + she's hard to follow
13. she's scared of how hurt she is
14. was it them; no, it's her powers
15. he ~~he~~ helps her out of her sleeve, ~~she says she's never damaged herself this much before~~
16. she says she's never damaged herself ~~this much before~~; her arm is badly cut and burned
17. he's upset; she has scars from earlier uses
18. she never wanted these powers
19. she goes to him
20. she's horrified that she hurt people, but doesn't know how to say it
21. she says she doesn't want to hurt anyone
22. he comforts her
→23. she doesn't think she can do this anymore — she's lost her resolve
↳24. what she did was bad, people are afraid of her
25. she's upset, she doesn't know if what she did was right
26. he reminds her she knew they'd turn against her but chose to do it anyway
27. she's still uncertain
28. he proposes they run away and forget it all
29. she doesn't have to be hero just because she got powers
30. that's not how she sees it ~~figures are obligated~~
30.1. she's just keen to say
31. that's not how he sees it, either, unfortunately
32. she's torn, uncertain
33. what she did was good and right, and they'll come to recognize that soon enough
34. she hates this gray area — she wants to do good, not question + be unsure
35. but standing by in the face of wrong is worse than being hated for doing what's right

36. the power is hers alone, so she has to make the decision
37. She considers it with her hands over her face
38. she has to stick to the original plan, she has to fight
38.1 he reacts
39. he vows to always stand by her, no matter the cost
40. She's touched
41. she thanks him sincerely
42. she suggests they get out of here
43. she stands with his help; saying she doesn't think she can walk; he says he'll carry her
44. he lifts her tenderly
45. as they ~~tromp~~ tromp through the forest, she asks if he really almost lost her
46. he smiles saying he knows her scent too well to ever really lose her
47. she leans against him; "That's good."
48. they are tiny silhouettes in the trees" Because you might have to track me a lot more often now."

Sandra Mellott writer

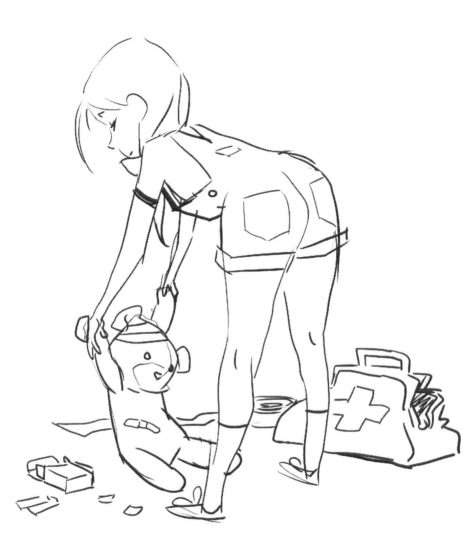

LEM 8/11

Lauren Montgomery artist

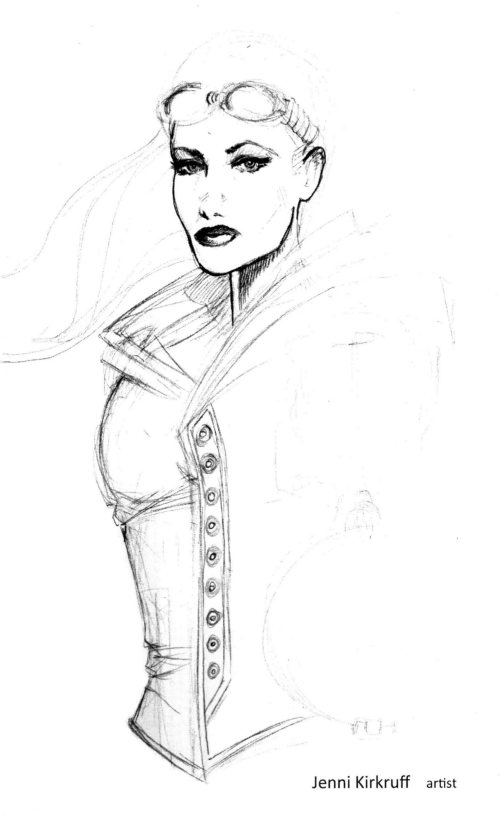

Jenni Kirkruff artist

Margarite

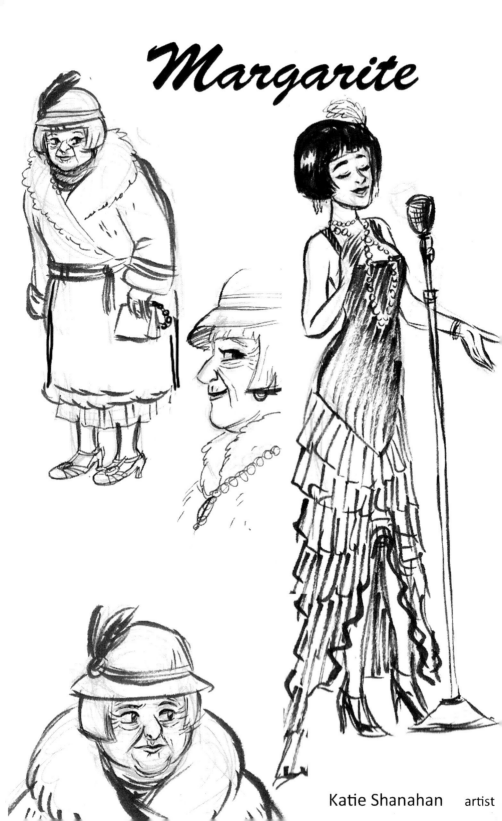

Katie Shanahan artist

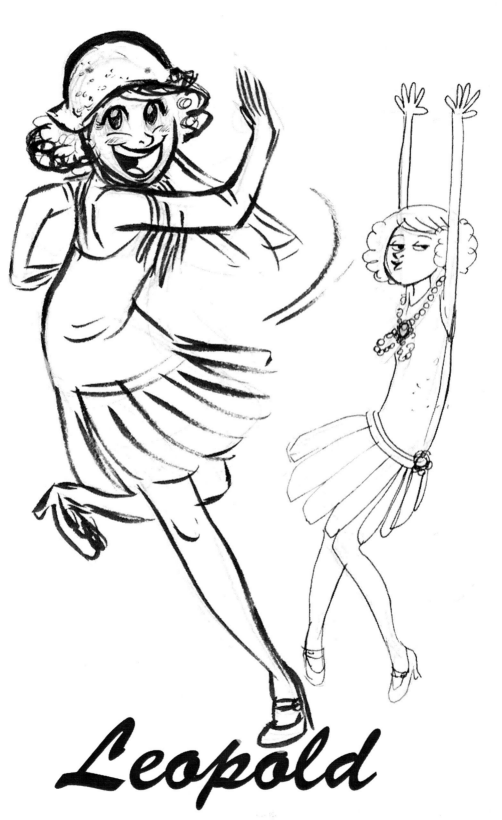

Leopold

everyday
Heros.

Darla Ecklund artist

Scene Set up: The hunter senses something following her. She's ready to pounce on whatever it is. She unsheathes her sword. The soul is introduced in this scene. I am not sure what I think the soul should look like (a bird or some sort of winged creature?). Something interesting of course, but I'm attached to the idea of it hovering/floating. On this page, the hunter encounters the soul and has a dialogue.

Caption 1: Then, one day when noon melted into dusk…

[SOUND EFFECT: CHHHKKKT]

THE GUARDIAN: Who are you?
THE SOUL: I am lost and without purpose; I fear I shall perish. Can you escort me to my master?
THE HUNTER: Who is your master?
THE SOUL: Destiny is my master.
THE GUARDIAN: What is destiny?
THE SOUL: I fear I do not remember. But I will know once it is upon me.

Page 3

*I agree with Mariah that there should be **some bonding going on between the soul and the hunter**, perhaps instead of all the different location scenes, there should be some illustration of the hunter being healed by the soul/creature after a nasty fight.*

Montage scenes:*Perhaps there can 4 to 5 panels outlining various scenes: she's all bruised and bloody and the soul heals her by shining some sort of magic essence on her body. Or, adding to the bonding phases, the soul is physically close to the hunter. I think a scene where the creature sleeping/resting and the hunter is shown keeping watch over it through the night or something like that. **Also, one of the scenes should be detailed to show the soul/creature in mid-rescue. I'm imagining the scene would depict it got snatched away by a nasty ghoul and the hunter has to chase after it. Could that be reworked a bit to show such more bonding/growth transpiring?***

Caption 1: The creature was as weary and lonely as the hunter. It wandered the treacherous vistas waiting and hoping for guidance. It did not come. Instead, the creature found a protector.

Caption 2: The hunter encountered a vulnerable, innocent thing.This creature gave her purpose in a hopeless world. And, without further question, the hunter becomes a guardian.
Caption 3: They begin their quest, traveling to more strange and unknown lands.

Caption 4: Meanwhile, many beings hunt the creature. Unnatural terrors stalk the plains, seeking to snatch the treasures of hope and promise.

Caption 5: The guardian sensed the creature possessed an essence like no other, radiating a subtle, beautiful glow giving light to hungry, dark souls.

Caption 6: It is a perilous journey to find destiny.

Raven Moore writer

PAGE 6, panel one
 Panels one and two are two equally-sized squares across the top one third of the page.
 Back in the counseling office, Hero is peering up at the counselor from over his templed fingers and under his bangs, as she smiles at him somewhat quizzically, charmed by him and trying to leave him enough room, emotionally, to go where he needs to go with his story.

 1 COUNSELOR: Why do you do it?

 2 HERO: Because it's the right thing to do?

Page 6, panel two
 Hero squirms under the counselor's gaze, playing with imaginary lint on his shirt, as she cocks her head attentively and broadens her smile.

 4 COUNSELOR: You don't sounds very convinced.

 5 HERO: Well…to stop the bad guys, then.

 6 COUNSELOR: And why do they do what they do?

Page 6, panel three
 Back to our flashback. Our superhero has jumped off of the roof and is shown here alighting in the chaos of the street below.
 The Firefighters are now working with the Jaws of Life (references at end of script) to free the girl from the backseat of the wrecked car as paramedics stand by with a transport board. A police officer is helping direct traffic in order to allow an ambulance to back up as close as it can to the car to minimize transport time once the firefighters get the girl out. Make sure to infuse everyone with a sense of urgency—these are our non-super-powered heroes.
 Civilians are still watching, their attention now off the roof and on the car.
 Broken pieces of the death ray are still visible on the sidewalk, in the street and on the hood of the smashed car.

 7 CAPTION: "Well, the super-villains want to rule the world, I guess. Whatever
 that means. And the mooks…"

Page 6, panel four
 Our hero, standing in the street near the smashed up car, is being politely pushed back by a police officer. We're not going to give him/her dialog but his/her expression and posture is clear ("Sir, if you'll please step back…"). Hero is trying to see into the car to make sure the girl is okay, as are most of the other already successfully corralled civilians.
 The firefighters have successful wrenched open the car.

Devin Grayson writer

Tat: "I'm bored. Let's go to the Realm."
Kali: "You know I can't today. I'm meeting Toby at Atreau's tonight and I want to finish up these rubbings. I'll never get back in time."

Panel 3: Kali looks at Tat, her work set down at the base of the gravestone. Tat cups her chin in her hands and is looking off into the distance, worry on her face.
~~Maybe~~ Tat: Please Kali.
Kali: All right. Let's go.

Panel 4: Kali packing her things away, rolling up her rubbing. Tat stands, her wings spread out behind her ~~to~~ delicate in contrast to the normalcy of her clothing, colored in reds, purples, yellows blending into each other reminiscent of an indian summer.
Kali: ~~a mixture of delicate and sharp. For a~~ ~~that lived so long, she sure doesn't have~~ ~~patience.~~ "I'm sure everything is fine Tat.
Tat: I can feel it Kali. There's an imbalance. ~~~~ And stop reading my moods. I'm trying not to worry you, but you know better than me how worried I really am."

Panel 5: Kali and Tat stand hand in hand ~~to~~ in front of 2 trees that form a doorway, their branches intertwining above their heads. The air shimmers, muted in color, between the two trees.

Jessica Daniel writer

★

Tat: "Ready?"
Kali: "Let's go."

PANEL 6: A grove surrounds the two. Ancient architecture sprouts covered in vines and flowers. Lamp posts with mushrooms sprouting from them. Towering oaks growing from the ruins. In the center stands a yellow cottage with a tree growing from the center. Everything is bright and colorful except for the two ravens sitting in the branches of the trees.
Tat: "Something is definitely wrong."

PAGE TWO

Panel 1: Close up of the cottage doorway with Feyn standing in the doorway. The bright, cheery nature of the cottage with daisies growing artfully around the house is in contrast to the dark nature of Feyn is tall and stately with sculpted perfectly proportioned features and pointed ears. Long limbs and long fingers with black hair that brushes his neck. He is dressed all in black with a vest embroidered in silver w/ scrolls & knotwork.
Feyn: "I knew you couldn't stay away much longer Tat. Everything is in place, all I needed was you. Come. It is time."

Panel 2: Feyn grabs Tat's arm, Tat looks as if she is trying to pull away. Kali is standing stock still and straight with her arms at her sides.

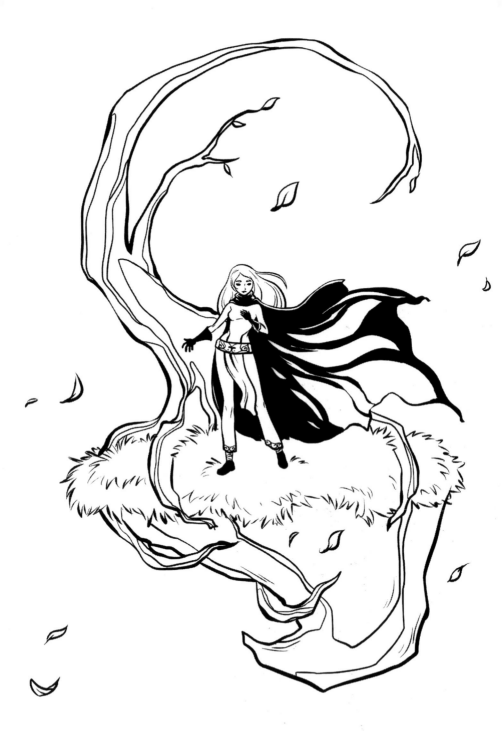

Alexis Hernandez artist

Panel 3

Somewhat narrow –

We see the queen in the foreground from a 180 switch. She places the mirror face down on a round tall table beside her and turns to face the visitors. In the background, partially hidden by shadows is a raggedy curtained 4 poster bed. It's very significant to the story, but for now, not much attention should be brought to it.

QUEEN, coldly:
It is only a common peddler. Your presence is not no longer required here, guard.

Second row,
Panel 1
vertical panel –
The queen is in the background with the four poster bed behind her. At this distance we can see that the table is between the queen and a tall standing mirror, held up by a clawed frame. The table's legs terminate in a large but delicate claw base, complimenting the queen's crown and the standing mirror. The queen, with one hand resting on the tall round table speaks to Snow White with royal disregard. Snow White, her hooded head and shadowed face in the foreground at a ¾ view from the back, trembles and answers.

QUEEN: You may approach us.

SNOW WHITE: Yes, your majesty.

Panel 2
Panel in panel 1, vertically-
Show the long toothed comb and three silver apples as vignettes, the comb on top and the apples beneath, with the text divided between them.

SNOW WHITE (above comb): Would your majesty care for this golden comb…

SNOW WHITE (above apples): …or this rare fruit?

Panel 3

Full figure shot: We see Snow White and the queen from a ¾ back shot as Snow White stands behind the queen, lacing up the bodice. We can clearly see the ribbons in Snow White hands as she tightens it. Snow White and the queen are standing in front of the mirror with the table slightly in the fore ground and we see their and the table's reflections facing us at a ¾ front angle. The three apples have been placed on the table as has the golden comb. The comb is closer to Snow White. Snow White's face is clearly visible in the reflection. The queen's eyes are clearly looking toward Snow White's face. The shadows around them spread out to gradually fill the spaces around the panels.

SNOW WHITE: Allow me to assist your majesty…

Peggy von Burkleo
storyboard and writer

Nicole Falk artist

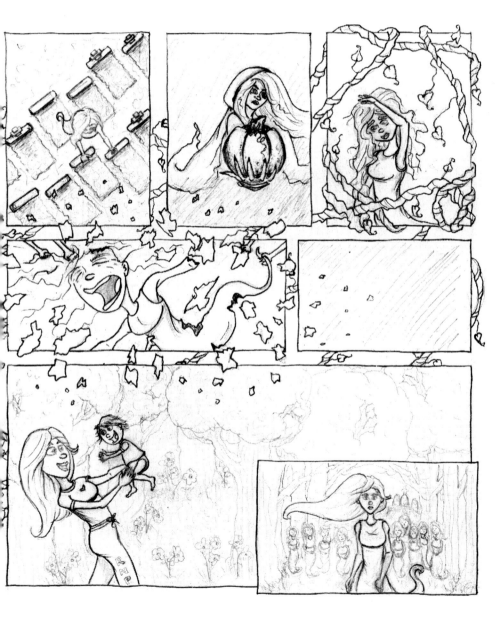

Jessica Hickman artist

Panel One:AJ is looking at the trail's crosswalk on Claremont Road. It is surrounded by yellow "DO NOT CROSS" tape. On the crosswalk is a person's body covered with a white sheet. A damaged, crumpled adult bike lies not too far away from the body. Police, emergency workers, onlookers, and a newscrew surround the yellow tape.

Newsreporter (She is an Asian Lady with Shoulder Lenth dark blonde hair and Brown eyes she has a square shaped face) "Witness described the car that hit and killed the victim to deputies as a newly painted dark green 1998 BMW with tinted windows. According to the authorities, this car is the same car that fled the scene of the five hit and runs that occurred last week. The car was last sighted heading east on Wagner Blvd. It appears that we have a serial hit & run driver on the loose. This is Mary Nguyen, Channel 9 Eyewitness News."

Panel Two: Moments later, AJ is hiding behind some bushes a on the trail. She begins to transform into her costume.

Caption: Six times. This makes six times this guy has eluded capture. And now a life has been taken.

Panel Three: It's a quick transformation, she wrapped in a bright purple cloak.

Caption:No more escape.

Panel Four: The cloak has disappeared and AJ is now in her costume. She is dressed in a purple spandex outfit that has the letter D in the middle. The D is designed: //>> in black lettering. Her face is covered by a black domino mask, eyes are glowing purple. Gloves are yellow and she wears zipped up black platform boots. Her skateboard is now in her right hand. Determination is on her face.

Caption: Today you will be caught by Defect.

Panel Five: Defect skates down the trail towards Wagner Blvd. The sun is now completely hidden from view, the sky is dark.

Talisha Harrison writer

Exterior, establishing deep space and in the center sits a SPACESHIP. The ship is older looking, there is nothing shiny or romantic about it. (Pictured as larger panel.)
title & Credits
Now we see the interior of the spaceship (and it matches the worn out look of the exterior). We are introduced to a dark, monochromatic, shabby "shanty town." All around are CHILDREN wearing tattered clothes. Their "homes" are ramshackle at best. This is our intergalactic orphanage. We see ASTER and ALEK on the outskirts.
We move in closer to the 2 children. Alek, a small, quiet boy of 9, is carrying bundles that appear to be clothing and blankets. Aster, his lanky, stoic sister, 15, is also carrying items with her. They are as tattered and disheveled as their surroundings. Alek has silent tears running down his round cheeks.
The children pass 2 BOYS, both wearing dirty outfits comprised of varying shades of tan and gray. The are sitting on the equally dirty ground arguing over what appears to be a small, plastic toy.
Boy 1
You've been such a jerk lately! Give that back!
Boy 2
Fine! I hate it anyway!
I miss mom.
alek
(quietly and to no one in particular)
I miss mom too...
Aster and Alek find an uninhabited corner and begin to lay out their things.
aster
I know you do, Alek. It doesn't matter though. They're dead and this is our life now.
The kids sit silently together, now settled into their new "home." There is a LARGE CHILD in their presence.
Larger boy
Hey, welcome. Nice stuff ya got there.
ASTER
Um... Thanks.

He is imposing and gruff, and also donning dirty clothing, although they appear less worn than some of the other children.
The boy is holding one of their items.
LARGER BOY
Sure. Why don't you just hand it over then. Nice and easy.
ASTER
What?
Before Aster can respond the boy GLEEFULLY robs them of their belongings. (I picture him with an armful of blankets and assorted textiles.)
Alek stands dumbfounded and wide eyed, close to tears. Aster clenches her fists and grits her teeth with rage.

Christine Makepeace writer

ALEK
Aster? He took our stuff.
Aster
I know.
ALEK
What now?
ASTER
How am I suppose to know?!
The 2 huddle together in the dark with only the clothes on their backs, shivering.
Aster's face is hardened with anger.

Jennifer Weber ariist

Ashlee Lentini artist

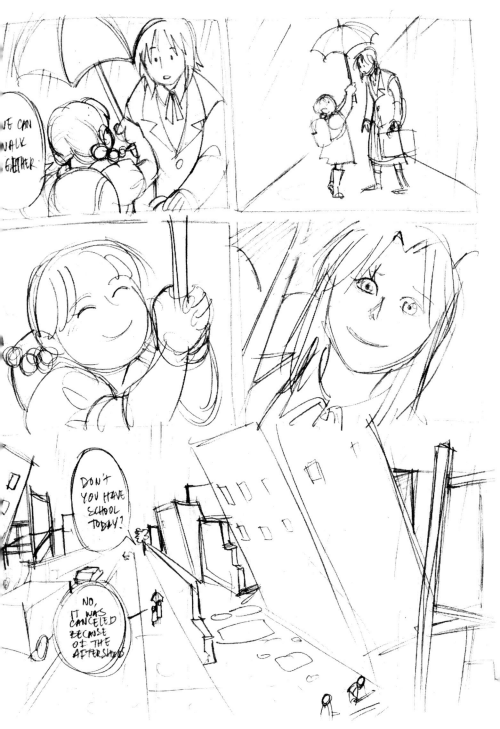

Irma Ahmed artist
Megan Metzger writer

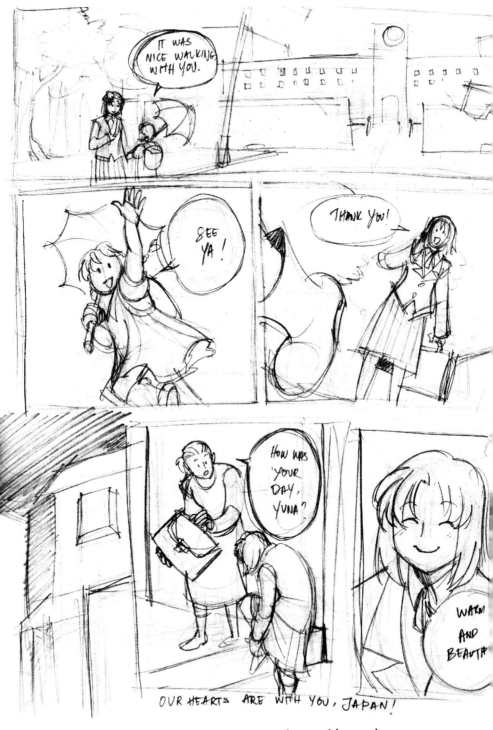

OUR HEARTS ARE WITH YOU, JAPAN!

Irma Ahmed artist
Megan Metzger writer

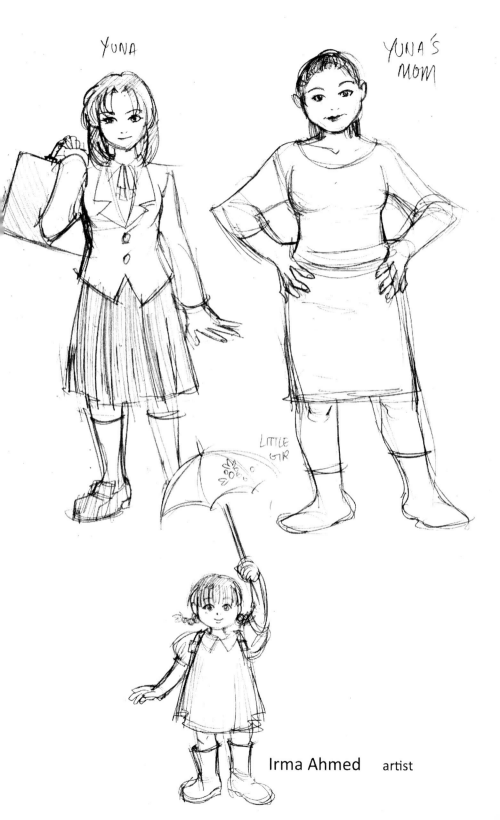

YUNA

YUNA'S MOM

LITTLE GIRL

Irma Ahmed artist

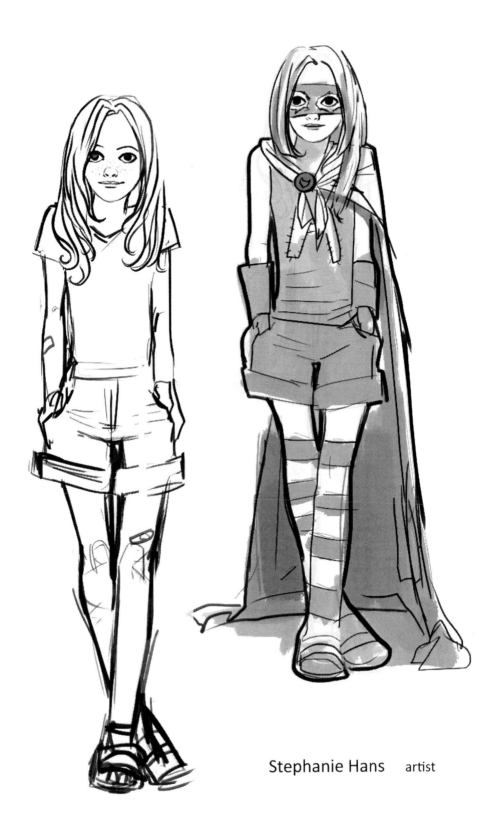

Stephanie Hans artist

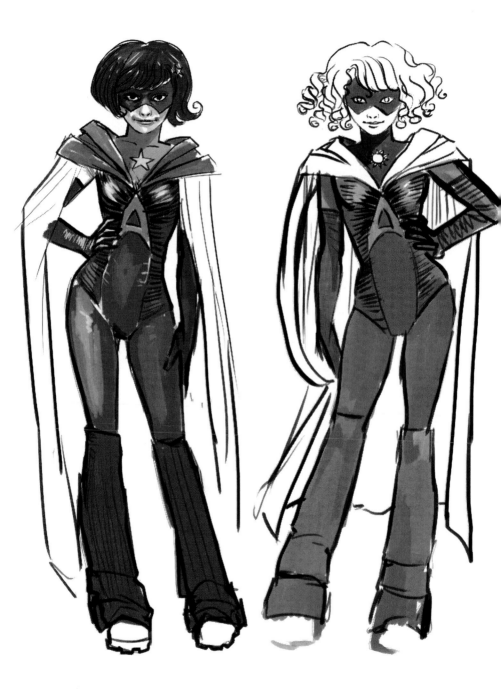

Stephanie Hans artist

Kelly Thompson/Stephanie Hans

SUPERLESS HERO

CONCEPT:
So the basic idea is that there are many ways to be "heroic". I'd like to go "funny" rather than overly "heartfelt". The vibe I'm going for is kind of like Powerpuff Girls - not necessarily the look of the visuals, but the feeling of it, kind of over the top superheroes /heroics played for comedy, with strong visual gags.

CHARACTERS:
AMY & ABBY – Sixteen year old twin sisters (maybe just give them different hair?). Attractive and full of life, they're superheroes (standard kind of "Superman package" superheroes) and good girls. They shouldn't be mean or cruel to their younger sister, but just realistic that she doesn't have powers and thus can't participate. As an alternative, we could do them not as twins and just as a 16 year old and 14/15 year old, that both have similar/the same powers. Either way works. Twins might be easier just from a time standpoint. Their costumes should be standard superhero fare, tights and capes, with a letter emblazoned on their chest (A's? Maybe A1 and A2 or something?), they should have little facemasks as well.

OLIVE – Between ten and twelve years old, the younger sister to Amy and Abby. Smart and funny, a little sarcastic and sassy. A little tired of having two very perfect and superheroic older sisters, but she loves them anyway, and like any younger sister, can't help wanting to be just like them. I'd say a young Daria, but a bit less with mean/harsh.

THE KID – A five year old kid (could be a boy or girl, your call Stephanie). He/she doesn't actually say any words, except "um". We're going for maximum cute factor here, like to a degree that it becomes funny, not saccharine.

THE CAT – The kid's cat. Should be insanely adorable, almost cartoonishly so. I'm thinking white, but you can convince me otherwise.

SCRIPT

<u>PAGE ONE</u> (8 Panels including title/credit block)

Panel 1. Title block (SuperLess Hero) and credits. Story by Kelly Thompson, Art by Stephanie Hans. I think "Less" should be slightly emphasized or all caps or something? Maybe here we would have room to do a little visual gag of the two sisters flying around with little Olive running behind them. It would be a good way to also establish the relationship and lack of powers in one quick shot.

Panel 2. Establishing shot of a family room, a big picture window that shows the empty front yard – and part of a tree outside. Two sisters (Amy and Abby – see character sheet) sit on a couch talking and their younger sister (Olive) sits on a chair reading a book.

Kelly Thompson writer

People are scared, and bad people do bad things.

Solar technology exists in a shady place: made illegal by gas industry lobbyists and un-American by their biggest political handmaiden (a young Congresswoman everyone expects is on a fast track to higher glory), it has spawned a renegade underground of scientists and tinkerers who want to see the light again through the murk.

One driven young inventor goes even further: she's developed a wearable form of stored power. Because of the illegal nature of experimentation, she's worked her discoveries into a fashionable mobile armor that refracts, reflects, focuses, and magnifies the power of light.

She calls it the GLIMMER SUIT.

It's a statement. It's a weapon. It's a business plan.

Because the best way to turn illegal tech into tomorrow's safeguard is to make it absolutely irresistible.

Sell a hero. Save the world.

Give 'em a little GLIMMER of hope.

Barbara Randall Kesel writer

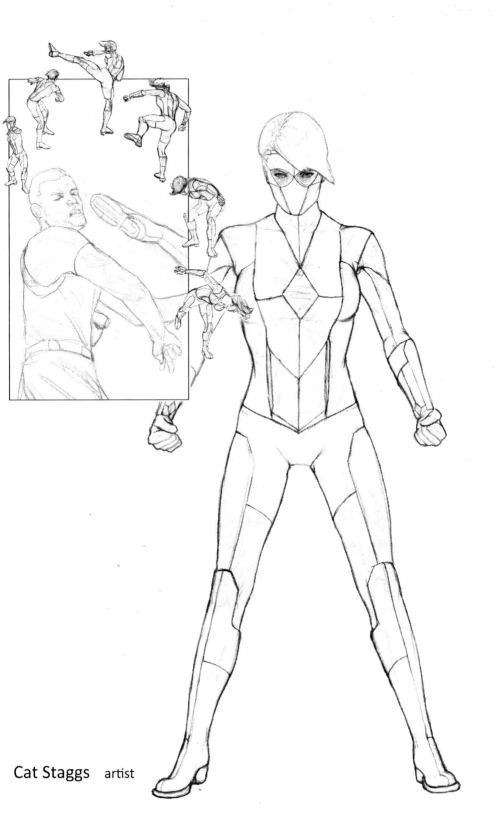

Cat Staggs artist

PAGE 2

Panel 1 (FLASHBACK, row 1):
Bright and sunny. Gran works planting seeds in a garden outside of tiny cottage, much smaller and plainer than Dia's. At Gran's feet sits LITTLE DIA, around seven years old. A tiny, bored version of her older self, half-heartedly tugging at a stalk of weed.

LITTLE DIA (singing): ...a king to save, a Beast to quell...

GRAN: Dia, stop singing to the weeds. It only gives them ideas.

Panel 2 (FLASHBACK, row 1):
The weed has come out of the ground and Little Dia holds it up to her face to study the intricate roots. Gran gazes beyond the fence, where the ground inclines up towards the tree line.

LITTLE DIA: It's just a song.

GRAN: Ah, but songs and stories have power. Armies have passed through here to their doom because of that very same tale.

Panel 3 (row 2):
In the present day, Dia makes her way through the woods, hiking upwards. Scattered here and there are pieces of skeletons – humans and horses – and old rusted armor. It's all long overgrown with intricate root systems.

CAPTION (GRAN): Even a simple nursery song could be the last bit of hope for a dying king.

CAPTION (GRAN): In the end, all that came of it was more death.

Panel 4 (FLASHBACK, row 2):
Little Dia gathers up the small rocks scattered about the garden plot, carrying them in her apron. Gran buries the seeds that she's already planted, creating little mounds of soil.

LITTLE DIA: But if everybody's all dead, then no one knows if Everwell is even real.

GRAN: It's real enough. There was one many years ago who succeeded in his quest. Only one.

Panel 5 (GRAN'S STORY; row 3 wide):
Gran's tale come to life: a stylized image of a forlorn young man gazing upward from the base of a mountain – the same mountain Dia herself is climbing in the present.

CAPTION (GRAN): No soldier or warrior.

CAPTION (GRAN): Simply a young man who sought to save the life of his dearest love.

Jody Houser writer

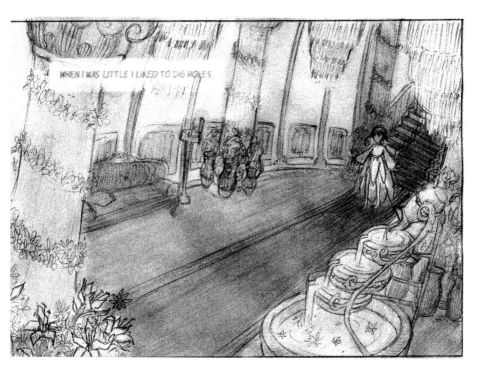

WHAT'S LOST IS LOST

LANA / HYPNOGOGIC LANA

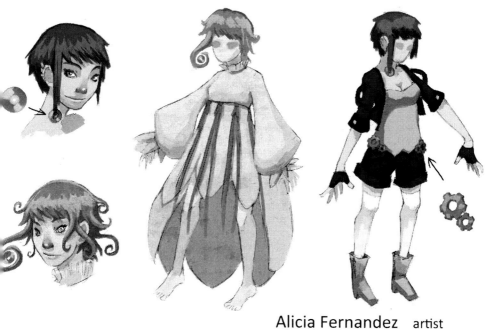

Alicia Fernandez artist
Annie Nocenti writer

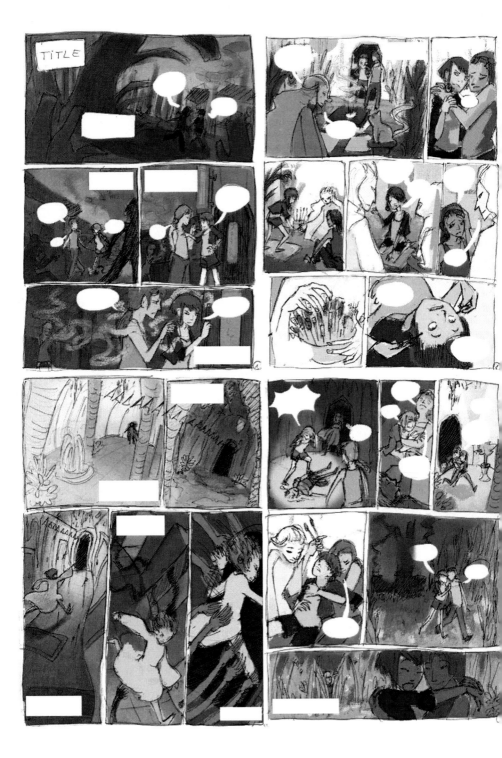

Alicia Fernández artist

WHAT'S LOST IS LOST

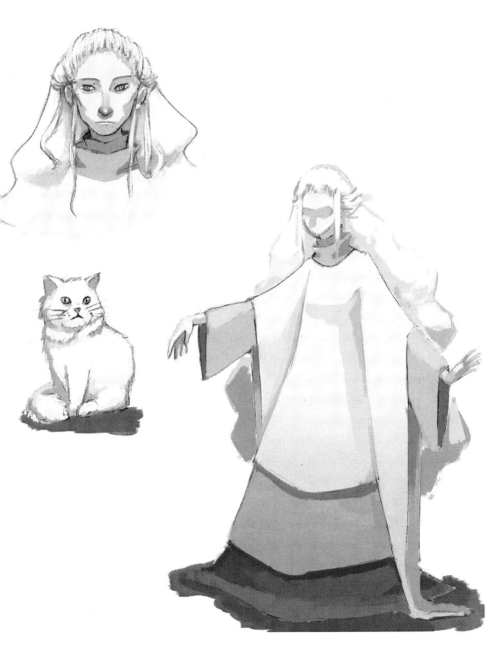

Alicia Fernández artist

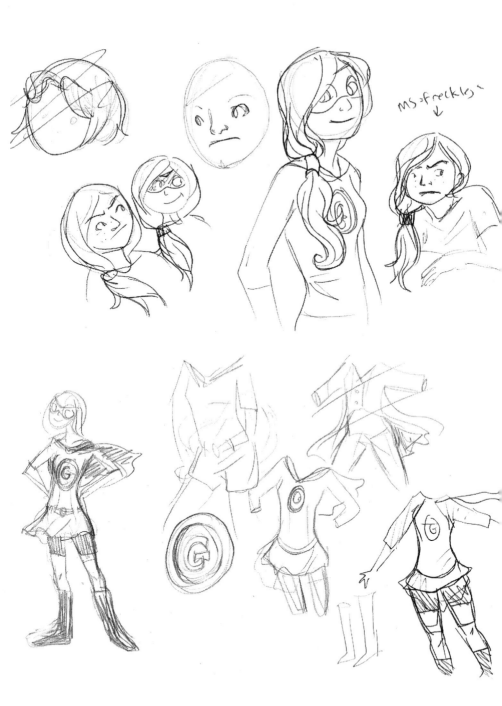

MS. freckles ←

Megan Brennan artist

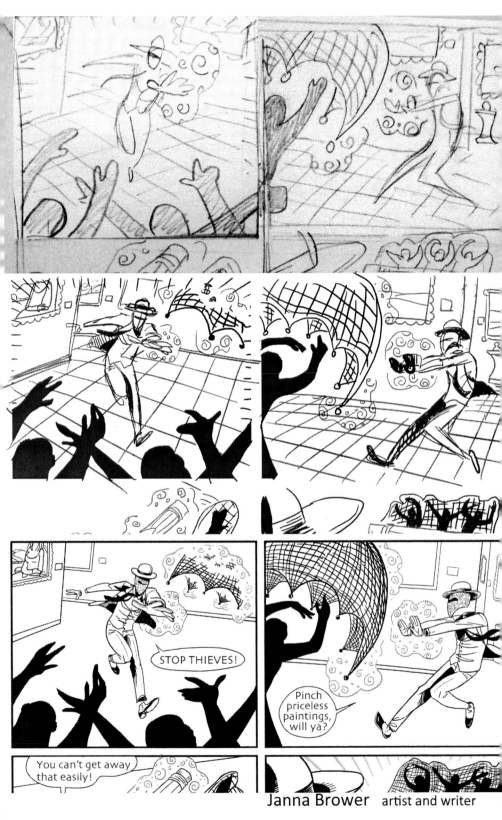

Janna Brower artist and writer

MARGARITE AND LEOPOLD

PAGE 1

PANEL 1: A photo of M from the same event (see panel 3): a close up of her on stage as she sings soulfully into her mic, gesticulating dramatically.

 CAPTION: "To the Misses Margarite"

PANEL 2: A photo of L from the same event (see panel 3): a close up of her on stage as she dances around M with joyful abandon (here is a reference video for dances from the 20s: *http://www.youtube.com/watch?v=yNAOHtmy4j0* - I believe the very first dance move or the dance that starts at 1:35 would work well for a static depiction).

 CAPTION: "and Leopold,"

PANEL 3: A photo taken from a table inside the main dining/performance hall at the MPH. Should show a sea of round tables packed with wealthy-looking guests in various states of drinking, laughing, and observing the musical number on stage. A scattered handful of these guests should be anthropomorphic animals (of your choice). L and M (both human, for the record) are on stage with a jazz band, and they are both in the middle of an energetic duet.

 CAPTION: "On behalf of all of us at the Marrow's Peak Hotel and Resort, allow me to congratulate you both on your upcoming 80th birthday."

PANEL 4: A photo of M and L posing in front of the Marrow's Peak Hotel. The hotel itself should be the main feature of the shot.

 CAPTION: "It was over 60 years ago that your renowned performances put Marrow's Peak on the map as one of the top hotels in the nation."

PANEL 5: A photo of M and L posing on either side of President Calvin Coolidge and the hotel manager in the lobby. L looks as if she's trying hard to contain how starstruck she is; M's aura of dignity rivals that of the President himself. The manager looks very professional in spite of the frilly vested monkey perched on his shoulder.

 CAPTION: "In honor of that legacy, I would like to invite you out of retirement to perform at the hotel's 100th anniversary celebration."

PANEL 6: A photo from below of M and L in their ski gear riding the gondola up the mountain, both acknowledging the cameraperson in their own distinctive ways.

 CAPTION: "Help us ring in this new era of merriment just as you helped us ring in the first."

Joamette Gil writer

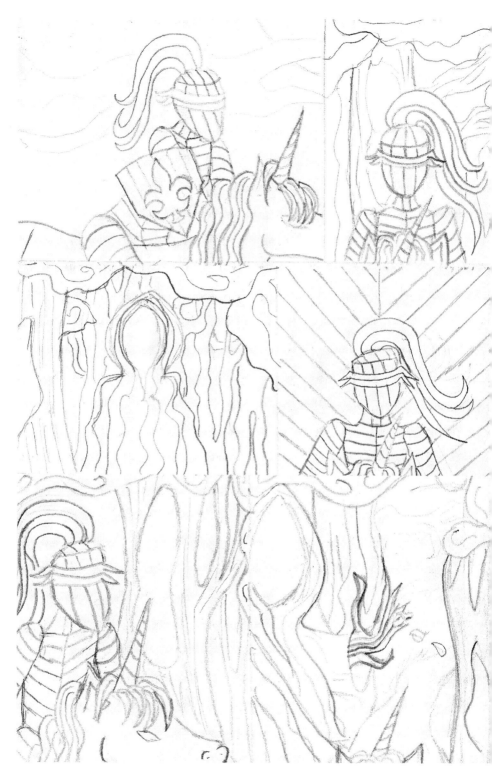

Nicole Sixx artist

What's Lost is Lost

by Annie Nocenti

STORY NOTES:

Futuristic world. What kind of future is this? Have the corporations of the US and the dictatorships that gutted treasuries finally fallen? If we take the domino effect of Arab Spring revolutions and assume it eventually hit China, America, Japan, etc.... I see this future world as littered with the monoliths to capitalist culture, now abandoned and decayed, similar to how after the fall of The Soviet Union the statues of Stalin were beheaded etc.....

But then, at the feet of all this dead corporate/dictatorial cultural monuments are lively, thriving NEW culture: be it steampunk cafes or multi-screen movie shops or holographic shopping spots, curio shops, magic and gypsy fortune booths... all labyrinthine and cluttered and complex, like a flea market or favela slum or bazaar in a third-world county... with insane darting children and feral animals, odd slinking glimmer of things you can't understand and snake oil salesmen types hawking oddities...

Page one.

Panel one

We open in such a place as described above, a land of decayed monuments, as GRIFFIN, a handsome young man, very wholesome looking, like he could be a carpenter or fisherman or something working class.... And his girlfriend LANA, an exotic beauty of great refinement... walk past the monoliths of the dead abandoned world and head to the thriving street culture that has blossomed below...

They are in the middle of a fight. Lana is striding with unstoppable determination and Griffin is trying to dissuade her. They look small in the shadow of a great, decayed, monument.

Griffin: Why stir the soup?

Lana: Because I want to know what's at the bottom of the pot.

Annie Nocenti writer

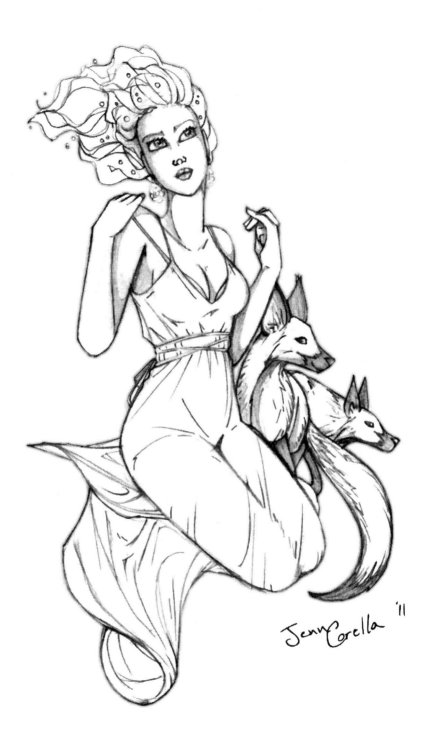

Jenn Corella artist

THE LITTLE STRANGER

PANEL 3: Let's show an image of one of Whitby's winding old streets. In the yellow amplight, let's show a black hellhound with glowing red eyes, and a mischievous fairy called a hob. Galloping along the lane is a black coach pulled by headless horses. Inside the coach are the animate skeletons of dead sailors. (Once again, see the photos at the end of the script for possible image ideas.)

CAPTION 3~~4~~: Gran told us never to walk Whitby's streets after dark. We might meet the mischievous hob, or see the Barguest coach.

CAPTION 4: Or worse yet, we might stumble upon the town's spectral hellhound. If we heard him bark, we would die soon after.

PANEL 4: Let's show Betty (the little sister) and the granny cutting lavender in the garden. It is very foggy outside. They are conversing about flowers. Meanwhile, our twelve-year-old protagonist is walking towards the gate. She has a backpack on her back.

5 BETTY (to Granny): What will we do with this lavender, Granny?

6 GRANNY (to Betty): We can make sachets and even ice cream!

7 BETTY (to Granny): Really?

8 CAPTION: But despite all of Whitby's ghosts, I spent most of the summer feeling restless and bored. ~~Betty was happy to work in Grandma's garden, but the~~The endless fog made me feel claustrophobic. (I think the art shows that Betty is happy, so, we can keep this about the main characters inner feelings.)

PANEL 5: Betty and Grandma have paused in their work and watch as our protagonist opens the gate. Betty looks stricken that her sister is leaving her. Granny looks sympathetic.

9 DISTANT FOG HORN: BROO-OOM

10 BETTY: Sara, don't you want to stay with us?

11 SARA: Sorry, Betty. I need to go for a walk.

12 CAPTION: One day~~, when the fog was thick and the foghorn was sounding,~~ I decided to break away from the safety of Grandma's house.

PANEL 6: Sara stands just outside the gate. Her little sister stands just inside it. She is looking up at Sara imploringly. She doesn't want to be left behind! Betty is still holding the scissors she used to cut lavender.

BETTY: Can't I come with you?

SARA: You won't be able to keep up.

BETTY: PLEASE! I'll walk really fast.

SARA: Well, Ok.

CAPTION: ~~As always, Betty wanted to tag along.~~ I let her come, though I knew I'd regret it.

Robin Furth writer
Mariah Huehner editor

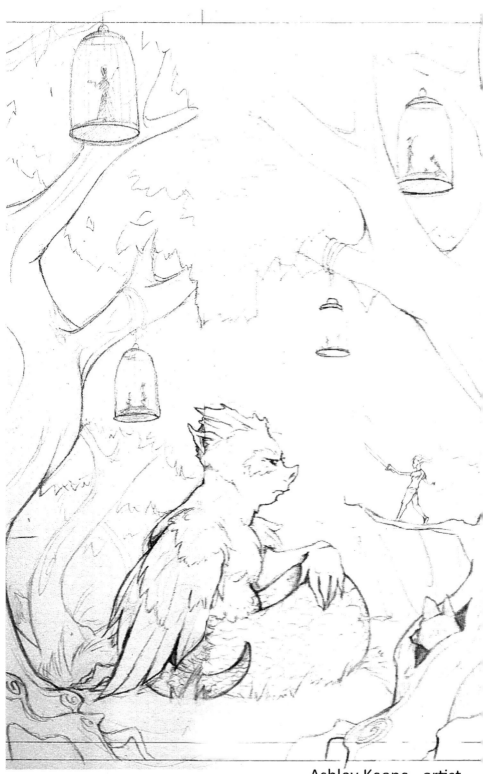

Ashley Keene artist

being HEROIC means

Doing what's right, especially when no one else will.

Knowing that some of the biggest help comes from the smallest gestures.

Doing what you've been told you're not capable of.

Knowing you can't fix others, only yourself.

Getting help so you can help yourself.

Doing the hard stuff again and again until it becomes easy.

Respecting other's choices for their life even when it hurts to watch.

Knowing when to say "No" and that it's ok to set limits when you say "Yes."

Getting up and doing it all again.

- Ma'at Crook, Writer

HEROIC
A WOMANTHOLOGY

Amelia Altavena artist

4.

Sherri Rose — artist
Jenni Goodchild — writer

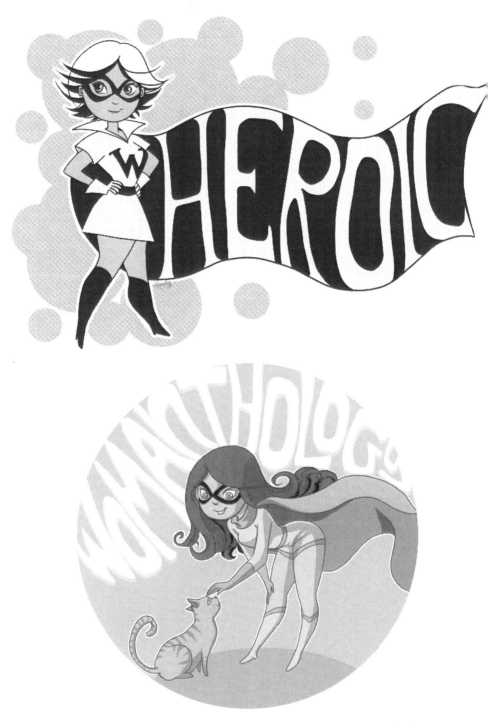

Hanie Mohd artist

Beck Seashols artist

Jean Kang artist

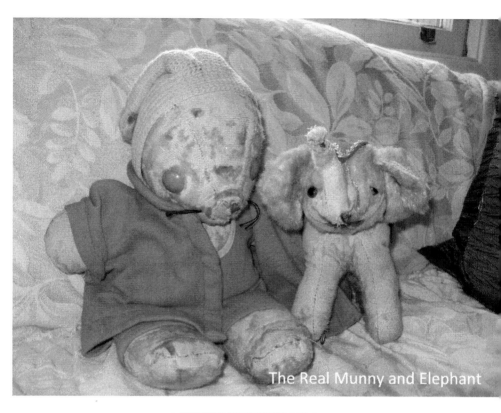

The Real Munny and Elephant

A STUFFED BUNNY IN DOLL-LAND
Words: Anya Martin

For WOMANTHOLOGY
Draft #1: July 24, 2011

PAGE ONE

Panel 1:

HALF-PAGE DETAILED PANEL

WIDE ANGLE: A conservatively furnished living room. In the panel, you can see three walls.

A doorway on the left with the front door open and just stepping inside are MOM and ANGIE. Mom is wearing a casual dress and holding a box of cookies. Angie is wearing jeans and a light purple short-sleeved shirt with ball sleeves and purple sneakers. She has her blonde hair in 2 ponytails. She carries 2 stuffed animals in her arms. MUNNY is a yellow bunny with big blue eyes and floppy ears (as if the wires are failing). Her shape is like a teddy bear/doll with arms and legs. Her fur is patchy and she is wearing an orange coat and pants. ELEPHANT is an elephant whose gray fur is also a bit patchy. His eyes are brown glass, and we see him in silhouette wearing a red circus costume with silver trim.

Anya Martin writer

INSERT PANEL(?): Tight CLOSE-UP on a few of the dolls' faces on the bottom row including one particularly creepy large BABY DOLL with a white bonnet and a pretty VICTORIAN DRESS DOLL in a red dress with white lace trim and a red hat with a brim lined in white lace trim. The dolls have blank expressions.

MOM: Hi, Mrs Taylor, so nice of you to invite us to tea. I brought cookies.

It's my pleasure!

MRS. TAYLOR: Welcome to the neighborhood.

ANGIE: These are my best friends, Munny and Elephant.

Panel 2

MEDIUM CLOSE-UP on MRS. TAYLOR, the silhouette of her face leaning into the frame as her, and her arms reaching out and taking Munny and Elephant from Angie. Angie's hands are empty and she looks a bit startled.

MRS. TAYLOR: How sweet. I bet they'd love to meet my doll collection.

Panel 3:

CLOSER AS MRS. TAYLOR hands placing MUNNY and ELEPHANT on a fancy floor cushion in front of the doll cabinet. In this panel, it should be apparent that one of ELEPHANT's eyes is broken – just a half eye.

Behind the two stuffed animals, dolls stare glassy-eyed, including one particularly creepy large BABY DOLL with a white bonnet and a pretty VICTORIAN DRESS DOLL in a red dress with white lace trim and a red hat with a brim lined in white lace trim. The dolls have blank expressions.

MRS. TAYLOR (VO in speech bubble coming off side of panel): Now come in the kitchen and let's find a plate for those cookies.

Panel 4:

CLOSE-UP on MUNNY and ELEPHANT. From their eyes, it should be apparent they are nervous. Meanwhile the eyes appear to have changed in the dolls on the bottom row behind them, especially the BABY DOLL and the VICTORIAN turning a little sinister (maybe slightly red) and seem to be grinning.

Anya Martin writer

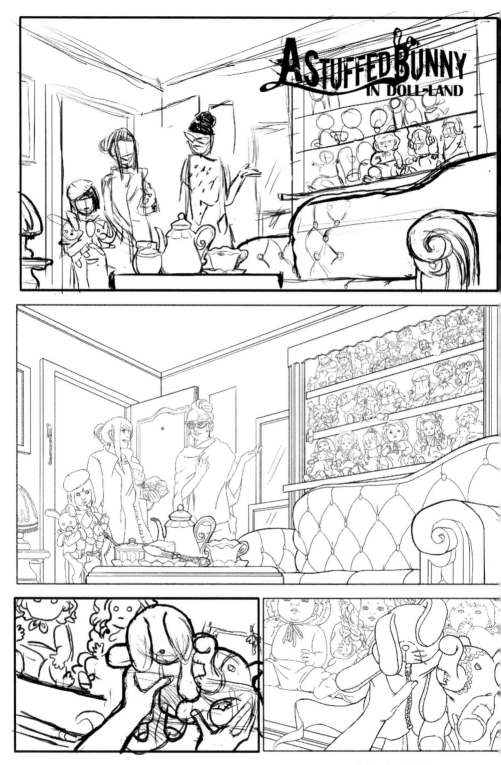

Mado Peña artist

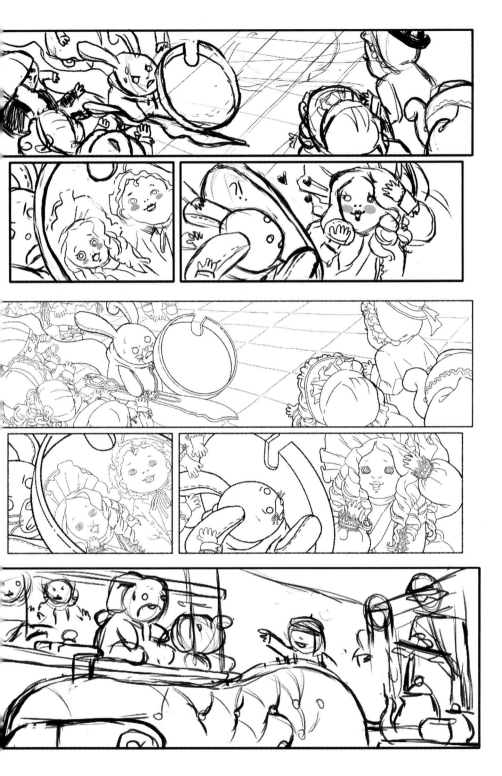

Mado Peña artist

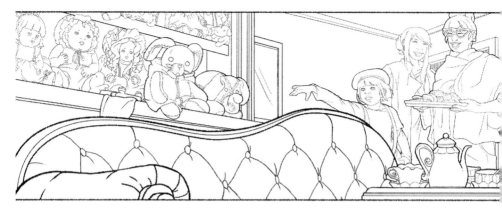

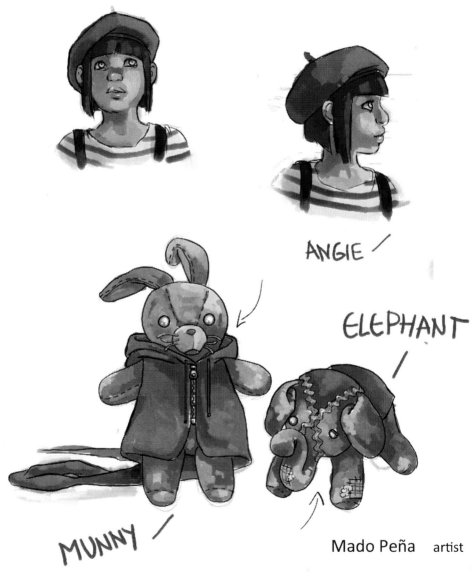

ANGIE

ELEPHANT

MUNNY

Mado Peña artist

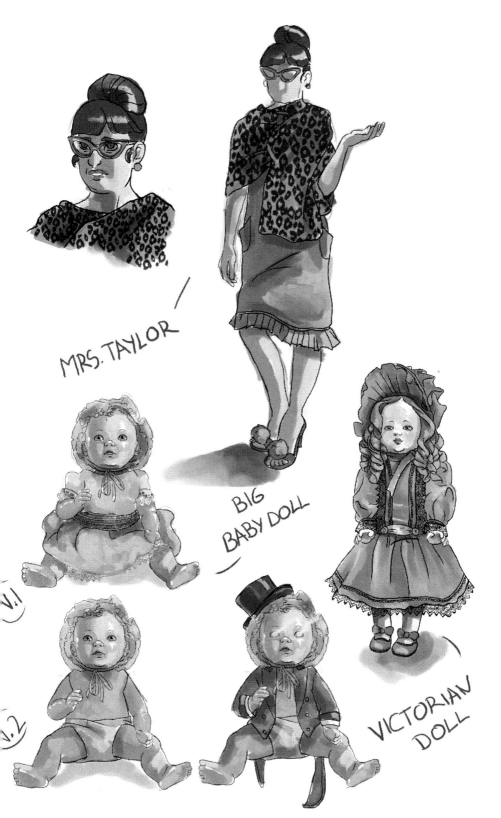

MRS. TAYLOR

BIG
BABY DOLL

VICTORIAN
DOLL

V.1

V.2

We all know the Earth is constantly spinning. We are taught why in Elementary school. But what if that's not the only reason?

In truth the Earth spins because of the power that humans provide it. This power comes from our actions and choices. "Good" actions make the rotation faster while "Bad" actions slow it down.

All over the world we have Doctors, Police Officers, Fire Firefighters, Social Workers and others who choose to dedicate their lives to making the world better and safer. They provide a constant stream of power and set the example for the rest of us.

There are also those who create the opposite effect. Dictators, murderers, criminals and the like all live for evil and cause a brake like effect on the planet. They leave a stain that breeds more hate and depravity in the world.

This slowing is offset by the little actions that we all do everyday. Holding the door for someone, picking up litter, helping someone in need, giving to charity, all things that give small bursts of power to keep Earth in motion.

Conversely, everyday small evils steal that power back. Acts of bigotry, hatred, vandalism, theft all cancel out the good and stall the Earth even more.

But the REAL POWER comes from those called the Watchers. A small few who at some point in their lives, will find themselves in a position to perform an act of great good. Even they are unaware of their potential, and they can be anyone, anywhere. That delinquent looking teenager across the street? Someday he is going to leap across a restaurant patio barrier to save a choking victim. That lazy looking construction worker on perpetual lunch break? His future has him stopping a purse snatcher from getting away. The elderly lady who is constantly in her garden? She will prevent a kidnaping from happening because she watches the playground across the street and sees the creepy guy and calls the authorities. Each of these acts, and those like them hit the earth with a huge jolt of energy and they are REAL super heroes. They are all around us and when the opportunity presents itself they will be filled with the senses of duty and honour and are compelled to act on them. There is only one thing that sets the Watchers apart from the rest of us before their destiny arrives, one way we catch a glimpse of who they really are; the angle of their hats.

All of this is for a reason as well. Everything truly comes down to good versus evil. Hovering above us, so far into space that he really isn't anywhere at all, Old Scratch waits. Biding his time until the Earth slows enough to wrap his claws around us all and end all traces of good in the world. So keep up the good deeds, resist the temptation do evil no matter how small and be ever vigilant. If you see someone who always seems to be looking around them, check their hat. And be ready to help them when the time comes.

Heather Royston writer

Elisa Féliz artist

Elisa Féliz artist

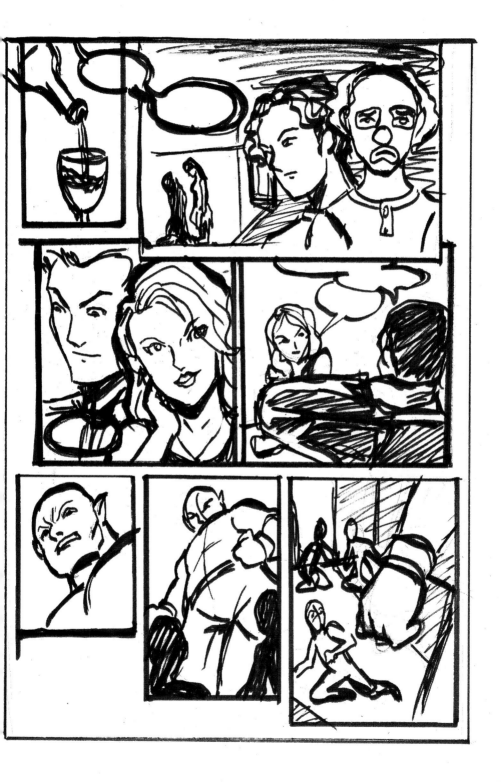

Cassandra James artist

Cassandra James artist

"Lost Treasure"
Story by Bonnie Burton
Lyrics by Samantha Newark from the song "Blue Sea"

PAGE ONE

PANEL 1

Description: Our heroine pirate girl has a determined look on her face as she looks through an old fashioned telescope at the ocean while sailing rough seas on her small ship. The weather is dark and forbidding and stormy....

(Song lyrics: LONG AGO AND FAR AWAY WHERE THE NIGHTS ARE COLD AND LONG...)

PANEL 2:

Description: She's now facing a large map pinned on the wall of the interior of her ship by the main wheel. She marks the map as though she's tracking her progress towards an X. She looks lonely and sad....

(Song lyrics: I WROTE A STORY IN MY HEAD ABOUT A PLACE WHERE I BELONG)

PANEL 3:

Description: Show the tiny pirate ship being tossed around the giant waves....

(Song lyrics: BUT THE SEA WAS ROUGH AND WIDE AND MY LITTLE BOAT SO SMALL)

PAGE TWO

PANEL 1:

Description: The pirate girl stands bravely on the bow of the ship as giant waves crash onto the boat almost knocking her over.

(Song lyrics: HOW COULD I EVER FIND MY WAY WITH THE WAVES SO BIG AND TALL?)

PANEL 2:

Description: The pirate girl's ship passes mermaids who watch her ship as it sails by

(Song lyrics: BLUE SEA CARRY ME LIFT ME UP HIGH SET ME DOWN DRY)

Jessica Hickman artist

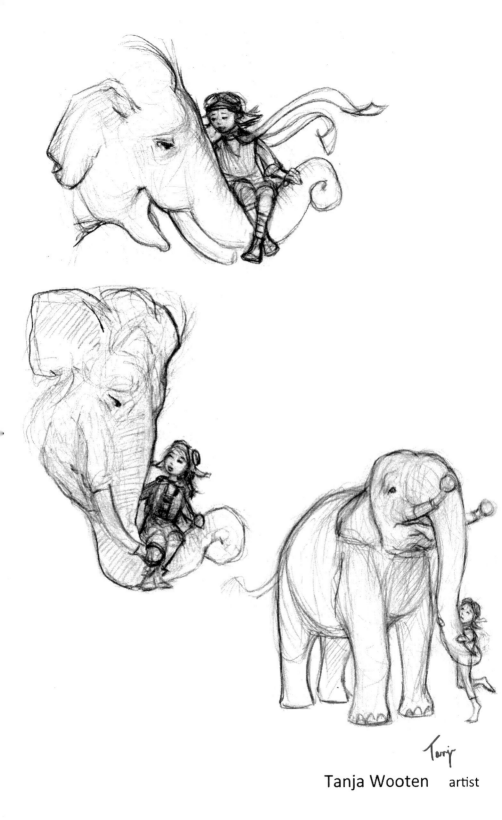

Tanja Wooten artist

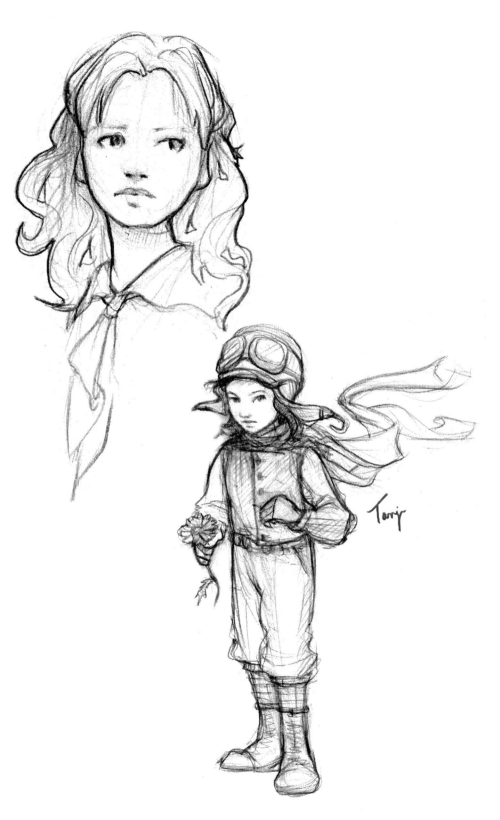

Tanja Wooten artist

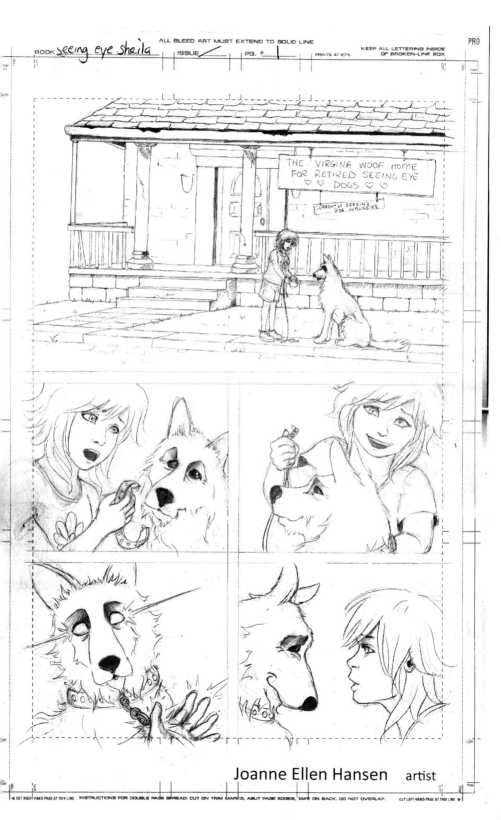

Joanne Ellen Hansen artist

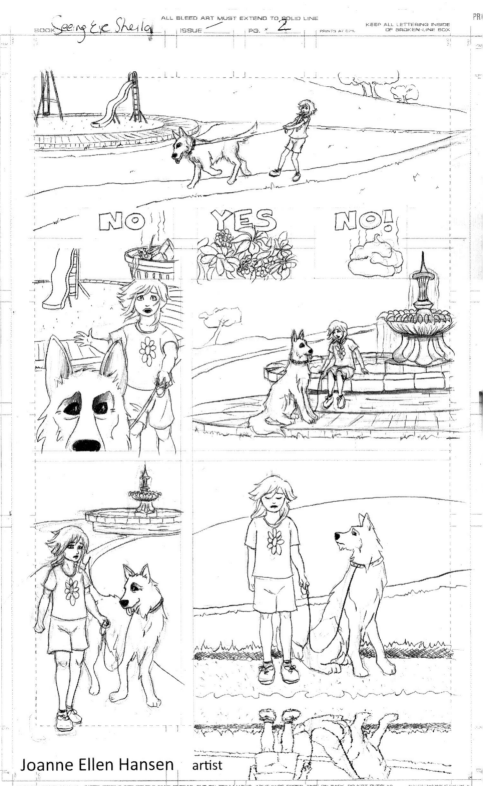

Joanne Ellen Hansen artist

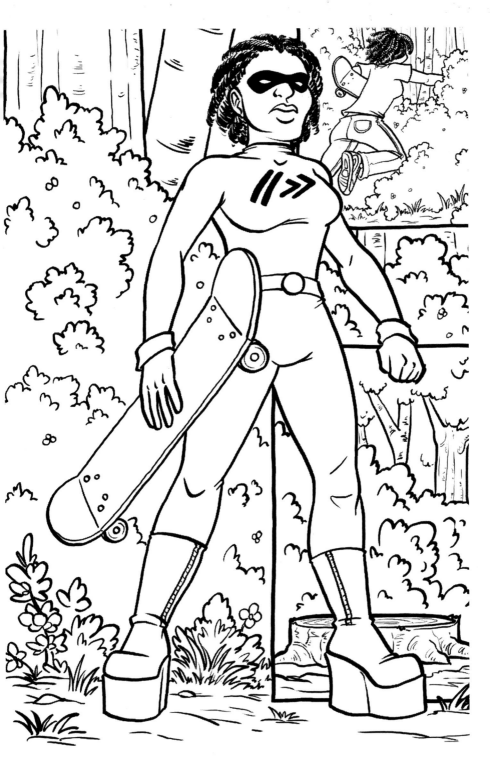

Kelly Turnbull artist

Andrea Agostini artist

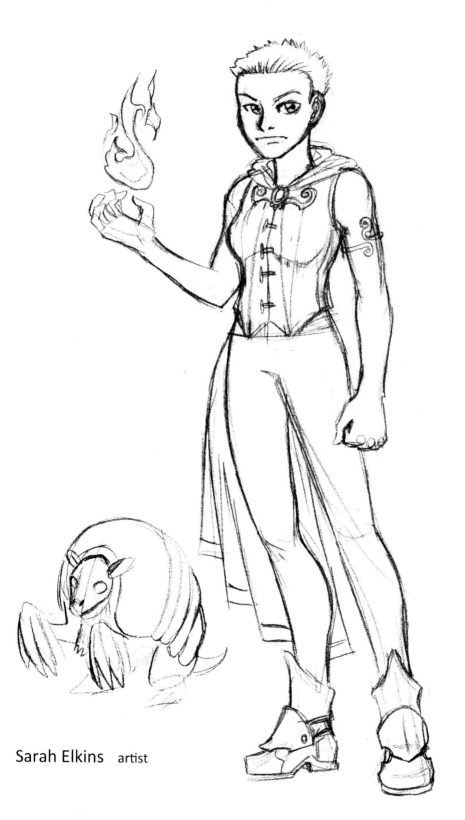

Sarah Elkins artist

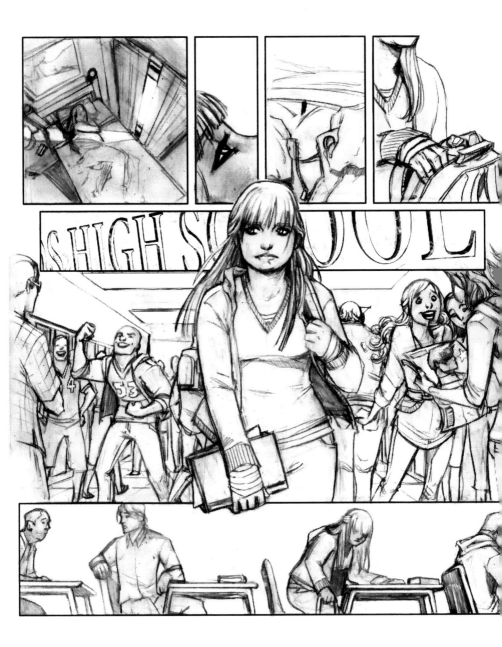

Renae De Liz artist

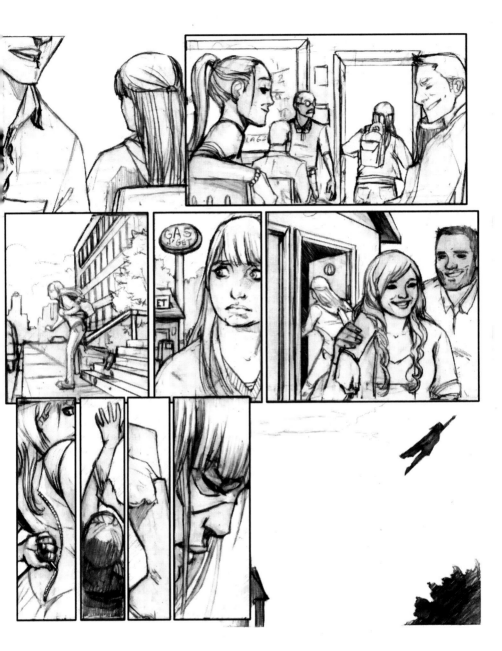

PANEL 6: The girl wakes up in a loft apartment where there are about
 10 other people, passed out, lying around the room. She
 looks around the room like she's lost, and knows that she'll end up
 losing herself if she stays.

Narrator: -Until the day I discovered you were a liar.

PANEL 7: The girl grabs her backpack, stuffing her things into it, one of which
 is a college application. Close up.

PANEL 8: The girl is looking through the door as she's leaving, and carefully
 and quietly closing the door. She knows she has to get out in order
 surviving again.

PAGE FIVE

PANEL 1: The girl is a woman now, cleaned up, and is graduating from college.

Narrator: And discovered that I was meant to be greater than that-

PANEL 2: She is walking away from a doorstep where she has left a card that
 says; "I forgive you." Tilted angle.

Narrator: And that my capacity-

PANEL 3: The woman is sitting at a circular table with a young girl who looks a
 lot like she did. The girl is very alternative with piercings and looks
 hard, and in pain, and especially unique. It is obvious that the woman
 is now a teacher who works with students who were a lot like her.

Narrator: And my heroism-

PANEL 4: We a hint of the Womanthology banner in the background and the
 blurry figures of some of the female "greats" in comics at a panel
 with crowds of women. Large panel.

Narrator: Was the story of all of us.

Amanda McMurray writer

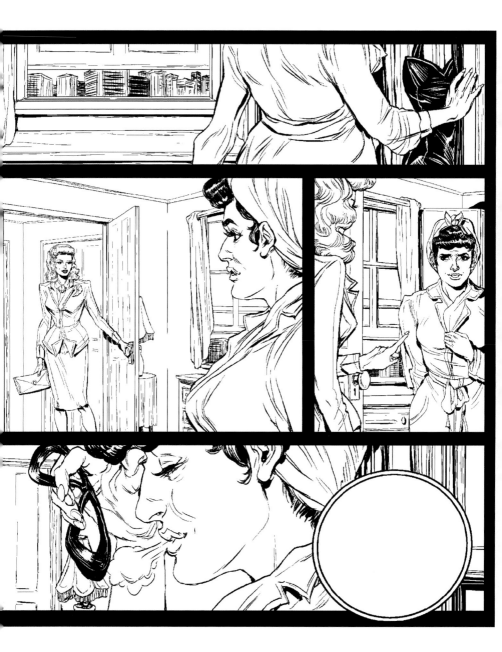

´Ming Doyle artist

Janet Lee artist

Janet Lee artist

SPECIAL THANKS TO:

MARY BELLAMY
CAT STAGGS
DARLA ECKLUND
RENAE DE LIZ

-JESSICA HICKMAN

ISBN-13: 978-1466424760 ISBN-10: 1466424761